NEW YORK

THE PAINTED CITY

NEW YORK

THE PAINTED CITY

GRACE GLUECK

GIBBS·SMITH
P
PUBLISHER

SALT LAKE CITY

03 02 01 00 5 4 3 2

This is a Peregrine Smith Book, published by Gibbs Smith, Publisher P.O. Box 667, Layton, Utah 84041.

Book design by Kathleen Timmerman

Apple icon by Alex Boies

On the jacket, *From Brooklyn Heights* by George C. Ault

Printed in Malaysia.

Library of Congress Cataloging-in-Publication Data

Glueck, Grace.
 New York: the painted city / Grace Glueck.
 p. cm.
 ISBN 0-87905-460-3
 1. New York (N.Y.) in art. 2. Painting. 3. New York (N.Y.)—History
 I. Title. II. Title: Painted city.
ND1460.N48G57 1992
758'.997471—dc20 91-40727
 CIP

—If I open the shades
You will see layers and layers of freshly cut
Plate glass, light splintering
The streets from a million windows,
And O the people! Everyone talking, laughing, dining out,
But you canot hear them. Here is one window
Filled with dancing couples, and in another
Four children are playing cards, and in that window
I think I see the horseshow at a concert:
The usual pearls and gloves, white shirt front,
Naked shoulder, and minutely printed on the folded play-bill
Held in a woman's hand, Romeo et Juliette.
 And in the windows
Everything to sell: the latest inventions
In copper wire, spun brass, gun-cotton, steel,
Even uranium, each almost perfect of its kind,
Sharp, clean, reflecting light—O a million lights,
Flood lights out of the dark,
Cross-beamed, white, yellow, red against the sky.
Shall I open our window?

— Horace Gregory

CONTENTS

EW YORK MAY not be as "painted" a metropolis as Paris, but if not, it's only because New York is somewhat younger. Like Paris, the city is a magnet for artists who come to market their talents and find its visual power irresistible. They get hooked on New York's soaring towers, its web of bridges, its bustling neighborhoods, its pastoral parks, its manic energies, its explosive mix of people, and the heady blue light of its winter afternoons.

When New York began as New Amsterdam in the early seventeenth century, there wasn't much to paint except portraits of dignitaries and the idyllic land and waterscapes that made up the city's magnificent site. But, as successive generations of immigrants settled in and commerce blossomed, the scene livened up. By the late nineteenth century, New York was an artist's dream. Besides the streets that bustled with horse-drawn traffic, there were well-groomed parks, an abundance of handsome houses, stylish department stores, smart hotels, music, theater and other performing arts, richly ethnic

slums, crowds and celebrations. What's more, by this time New York knew what it was. It had the deep self-confidence and cocky air of a powerful metropolis, "the most extravagant of cities," as Henry James has called it. Not only did it provide infinite material for artists and writers, but a sophisticated audience to respond to their efforts.

Before the turn of the century, artists like William Merritt Chase and Childe Hassam took a privileged, upper-class view of the city, using as subject matter its more monied inhabitants and the areas they frequented. Chase often painted Central Park, the parts where elegant people strolled, children played watched by nannies, and expensive carriages rolled along behind high-stepping horses. Hassam also recorded high life: the watering places of the wealthy, the grand boulevards of Manhattan, and the swarms of hansom cabs that hovered near fancy hotels and restaurants.

But in the early 1900s, along came the group of gritty urban realists known as the Eight, or the Ashcan School, among them John Sloan, Robert Henri, George Bellows, George Luks, and William Glackens. Mostly Philadelphians who had emigrated to New York, they focused on the raw vitality of the city, seeing it as a place of immigrant striving and ambition. But they were after more than just the facts of life as experienced by the poor and working classes. They admired the dynamics of the burgeoning metropolis: the elevated trains that roared through neighborhoods, the gigantic excavations that signaled New York's headlong growth, the parks and playgrounds—like Coney Island—that provided recreation for the masses. Though their work seems tame enough today, in their time it was considered daring, even outrageous.

By the 1920s, New York had seven million inhabitants. Not only was it the richest, the biggest, and the most cosmopolitan city in North America, it

took its place alongside the great capitals of Europe. An account of the era says that New York factories made more than half of the clothing worn in America, the city boasted nearly three million telephones and forty-three newspapers, and its citizens smoked seven million cigarettes a day. The metropolis was in its high-energy heyday, poised unknowingly on the brink of the stock market crash of 1929 and the Great Depression that was to follow. The authors of a 1923 guidebook wrote:

> The first characteristic of New York which impresses the stranger from abroad, and in a less degree from other American cities, is its atmosphere of breathless haste, its pervading sense of life keyed to an abnormal tension. The acute discomfort of the morning and evening rush hour, when streets are gorged with tramping thousands of toilers, and every car is jammed with close-packed human freight, is only one manifestation of the city's ruling passion. Everywhere and all the time the surge and roar of traffic goes on, varying only in degree; everywhere is the same feverish energy, the same impatience over a minute's loss.

A glamorous symbol of New York's "feverish energy" and, well, upward mobility, was the skyscraper, which took its name from the very top sail on the old clipper ships. Earlier towers, like the Singer Building (1908), the Bankers' Trust Building (1912), and the Woolworth Building (1913), paved the way for much larger edifices. New York was minding the country's business; it needed office space, and by the 1920s, skyscraper fever gripped the city. Buildings multiplied, rearing higher and higher, and a new skyline came into being, ranks of soaring structures crowned with an awesome array of cloud-piercing tops. By 1931, those two great New York icons, the Empire

State and the Chrysler buildings, were solidly planted in the city's tough bedrock. These and other towers of technology, with their clean, angular profiles, inspired a number of artists—George Ault, Georgia O'Keeffe and Charles Sheeler among them—who took a romantic view of the skyscraper, but worked in the cubist-derived mode of precisionism, distinguished by its geometricized forms and sharply outlined contours.

The Depression took the wind out of New York's sails, and cast a pall over the city that was to last for more than a decade. The lonely, down-at-heels atmosphere in Manhattan paintings of the 1930s by Edward Hopper seems to mirror the city's malaise. Morris Kantor's *Farewell to Union Square*, 1931, in which a trio of giant roses lies elegaically on the street, could be read as an intimation that an era was slipping away. But as New York recovered, in the days before and during World War II, a more upbeat imagery began to emerge. Piet Mondrian celebrated the revivified energy of Manhattan in *Broadway Boogie-Woogie*. And for *The Brooklyn Bridge, Variation on an Old Theme*, Joseph Stella went back to paint the bridge again after a long hiatus, finding a new excitement and urgency in his old motif.

In the decades since the war, New York has changed considerably. One of the most obvious shifts has been the broadening of New York's ethnic mix, as reflected in the recent painting by Bill Jacklin, *Sheep Meadow III*, which shows a "gorgeous mosaic" of New Yorkers enjoying a pleasant day in Central Park. But, as with many other American cities, there are difficulties that severely compromise the quality of life in the metropolis: the flight of middle-class families to the suburbs, the loss of industry and skilled labor, the drug problem. Artists have not ignored these changes; in this book they are reflected in paintings by Jane Dickson, Roger Winter, and James Romberger. Theirs is a very different vision of the city from that of, say,

Charles Hoffbauer, whose 1904 *Roof Garden (Study for "Sur Les Toits")*—presenting a group of swells dining at leisure in an elegant roof-garden restaurant—is a metaphor for a New York long gone.

But New York, for all its difficulties, is a survivor, still a lure for creative people and those adventurous enough to tackle urban life at its most challenging. And in good times or bad, its spectacular environment and astonishing concentration of humanity will never lack for artists to record them.

— Grace Glueck
New York City, 1992

*O*N A HIGH BLUFF overlooking the East River, with a superb view of New York Harbor and downtown Manhattan, Brooklyn Heights is one of New York's glories. Settled in the seventeenth century by Dutch farmers who crossed the river from Manhattan, it was built up by their prosperous descendants. Over two centuries, the Heights became a virtual encyclopedia of American architecture and its stock of houses, many of them high-style mansions, form one of the country's most beautiful urban areas.

The view depicted by George Ault in this jauntily stylized painting can be seen from homes along the Esplanade, the broad walkway atop the river bank on the Brooklyn side. Beyond the docks, factories, and warehouses that line the shore, a freighter plies its way upriver; behind it are the skyscrapers of Wall Street and Lower Manhattan, enveloped in cottony billows of factory smoke that today would make environmentalists blanch.

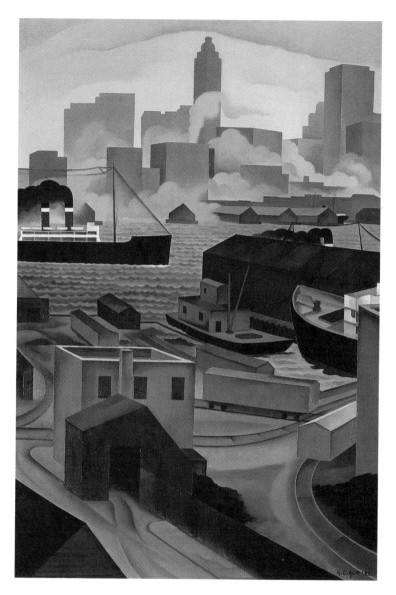

FROM BROOKLYN HEIGHTS
George C. Ault, ca. 1925, oil on canvas, 30 x 20 inches.
Collection of the Newark Museum, Newark, New Jersey
(Purchase 1928, the General Fund).

*Y*OU CAN SEE anything from a New York window, even a naked woman standing on a rooftop wearing only her shoes. And, in fact, the nude in this painting is completely unselfconscious. Enjoying the midtown view, she seems as at ease in her exposed circumstances as she would in her own bedroom. The oddness of her presence is in sharp contrast with the flat ordinariness of the roof and the calm sky; in fact, her placement there could be the artist's witty comment on the surreality and strangeness of life in Manhattan.

George Ault (1891–1948) was mainly associated with the precisionist school of American painters that flourished in the 1920s and 1930s, known for the cool detachment of their sharply contoured, geometricized forms. Ault brought to the style his own poetically surrealist sensibility, one well-attuned to the romantic, glamorous city that he knew in the days before World War II.

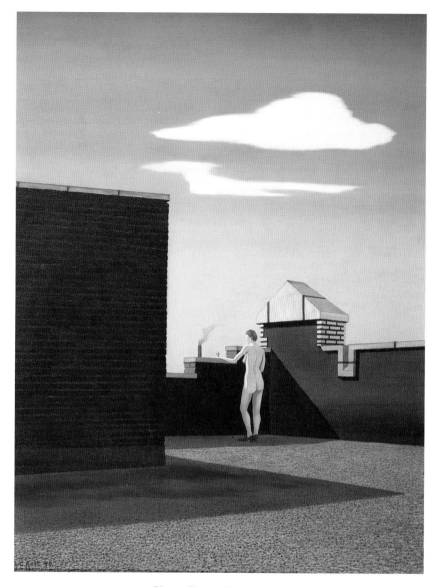

NEW YORK ROOFTOP
George C. Ault, 1940, oil on canvas, 26 1/2 x 20 1/4 inches.
Private collection. Courtesy of the Hirschl & Adler Galleries, New York City.

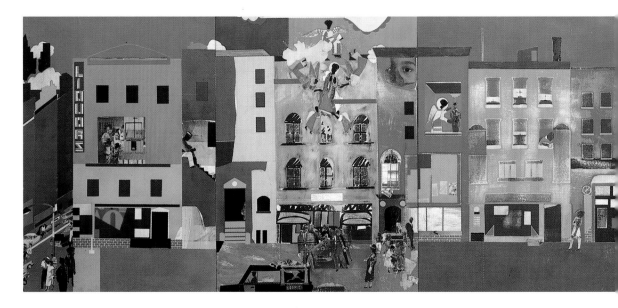

EARLY 325 THOUSAND people live
in Harlem, a long triangle bounded
north and south by 110th and 155th
streets, and on the west and east by
the Hudson and the Harlem rivers.
Formerly a fashionable residential area, Harlem evolved, after the turn of
the century, into one of the largest black communities in the United States.
By the 1920s it had developed a rich culture. Jazz, nightlife, sports, and

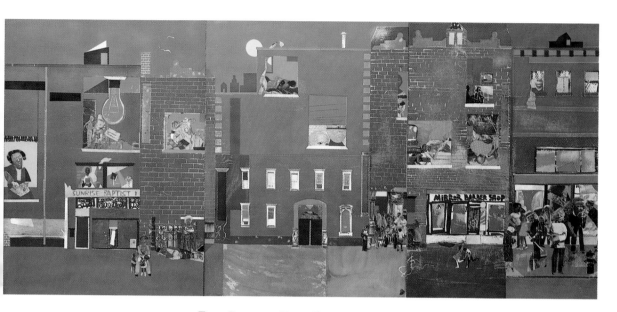

THE BLOCK, THE FABRIC OF MANY LIVES
Romare Bearden, 1971, cut and pasted papers on Masonite, 6 panels—each 49 x 36 inches.
Collection of the Metropolitan Museum of Art, New York City
(Gift of Mr. and Mrs. Samuel Shore, 1978).

high style flourished there, and artists and writers, among them Romare Bearden, Jacob Lawrence, Countee Cullen, Langston Hughes, Richard Wright, and James Baldwin, drew inspiration from the vivacious streets and neighborhoods.

In this huge, six-part collage, Bearden (1914–1988)—noted for his vivid melding of paint and cut-paper elements—evokes a Harlem block teeming with activity, its tenements bursting at the seams, its stores, its church, its barber shop, its poolroom, and its lively mix of locals.

F LOATING ABOVE THE bustle of the city, New York's famous web of bridges spans two waterways, the Hudson and the East rivers, tying the island of Manhattan to its sister boroughs. Some of the bridges, like the Brooklyn and the soaring Verrazano-Narrows, are ranked among the world's most beautiful.

The two bridges in Leigh Behnke's diptych are dramatically portrayed by means of extreme changes in scale. The top half of the painting closes in on the girders and trusses of the Brooklyn Bridge. Above it is a bird's-eye view of Manhattan, looking uptown, with the Empire State Building looming left of center. In the lower half of the painting, in very small scale, is the neighboring Manhattan Bridge, seen from the top of the World Trade Center.

Leigh Behnke, a devotee of New York, lives in the city and uses a camera to record the images she later translates into paint. Her sharp shifts of viewpoint are in tune with the dynamics of New York City life.

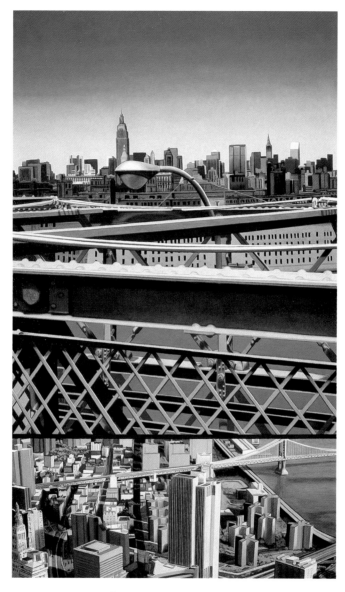

BRIDGE PROMENADE
Leigh Behnke, 1991, oil on canvas, 40 1/4 x 24 inches.
Courtesy of the Fischbach Gallery, New York City.
Photo by Plakke/Jacobs.

*T*O GENERATIONS OF New Yorkers, part of the fun of growing up in Manhattan is sailing model ships in Central Park's Conservatory Water, better known today as the Small Boat Pond. A mecca for kids, the pond is one of the countless opportunities for diversion—from bird watching to strolling to roller skating to horseback riding to outdoor theater—offered by the park, set smack in the middle of Manhattan and one of the world's great recreation areas. Designed by Frederick Law Olmsted and Calvert Vaux, and officially opened in 1876, the park, with its acres of dramatically landscaped lawns and waters, quickly became the city's backyard, and has remained Manhattan's most beloved open space.

William Merritt Chase (1849–1916) had an eye and a feeling for upper-class life, and these well-behaved New York children at their decorous play are subjects that suited him. Like most New Yorkers, he was fond of Central Park, and saluted it in a number of paintings.

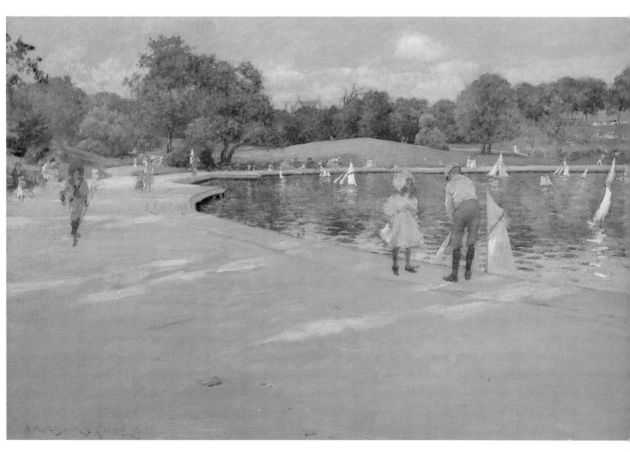

LILLIPUTIAN BOATS IN CENTRAL PARK
William Merritt Chase, ca. 1890, oil on canvas, 16 x 24 inches.
Collection of Peter G. Terian, New York City.

*T*HE MIRRORED BUREAU was probably the largest piece of furniture in the small tenement flat depicted here. It reflects the mean streets of the Lower East Side and a piece of the Manhattan Bridge, but behind the bridge loom the haughty office and apartment towers where the monied life of the city is centered. The artist has fun with this painting-within-a-painting. Trapped within the room by the mirror, the skyscrapers lose some of their dignity amid the squalor, which includes a bottle of gin almost as big as one of the outdoor buildings.

Glenn O. Coleman (1877–1932) was born in Ohio, but came to New York City in 1905, where he studied with two artists of the Ashcan School, Robert Henri and Everett Shinn. Fashionable New York had little appeal for Coleman, who painted the city's back streets and lower-class life from first-hand experience.

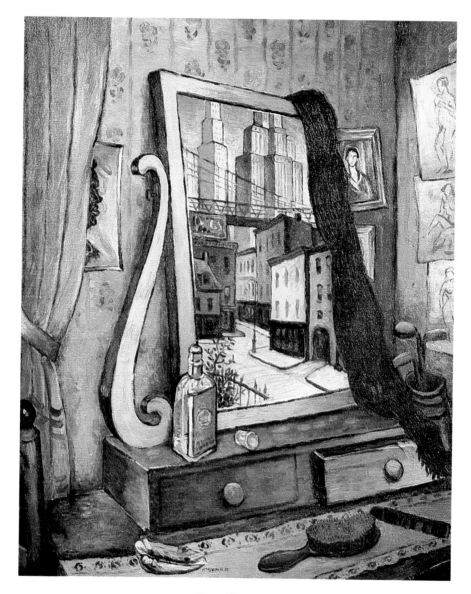

THE MIRROR
Glenn O. Coleman, 1927, oil on canvas, 30 x 25 inches.
Collection of the Whitney Museum of American Art, New York City.

HOT TOPICS FOR New Yorkers in the early 1930s were Prohibition, corruption in city politics, and the rapidly changing skyline. All these themes and more are packed into this dynamic mural. Begin with the towering Empire State Building, then the world's tallest, which tops the structures in the mural's center. A white sail behind the skyscraper pokes fun at the fact that its spire was unsuccessfully designed as a mooring mast for dirigibles; the sail also comments on New York's stature as a major port.

The building—along with the brown derby next to it—is also a symbol of Alfred E. Smith, the beloved politician who served as New York State's governor for most of the 1920s. At the time of this painting, Smith—retired from office—was president of the corporation that ran the Empire State Building. Ardently against Prohibition, he carried his fight for its repeal into private life. The moon in the top left of the mural, which drinks from a cocktail glass turned on its side, stands for "moonshine," the term for illegally made whiskey, and is meant to suggest Smith's involvement in the battle.

At the right side of the painting, a tiger's head and tail stand for Tammany Hall, the Democratic political machine which ran the city, off and on, for well over a hundred years. In the early 1930s Jimmy Walker, New York's Tammany mayor, was under investigation for accepting a bribe; he was later forced to resign. The crooked tiger tail refers to Walker and other officials associated with him, and maybe also to the cane that the jaunty Walker habitually carried.

Stuart Davis (1892–1964) was a sharp observer of what made New York run. Like most of Davis's mature paintings, this complex riddle-on-canvas reflects cubist influences as well as those of jazz rhythms.

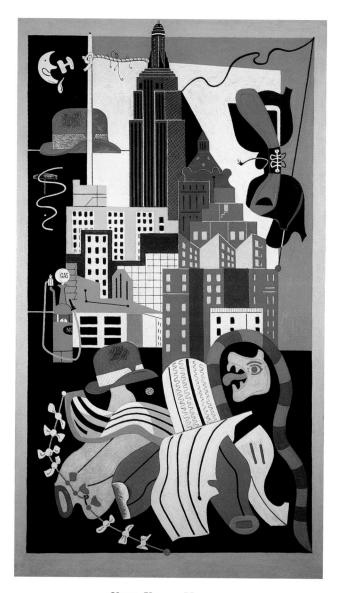

New York Mural

Stuart Davis, 1932, oil on canvas, 84 x 48 inches.

Collection of the Norton Gallery of Art, West Palm Beach, Florida.

NCE THE HEART of the Great White Way, brilliantly ablaze with light from theaters, fancy restaurants, and the diamonds worn by their patrons, Times Square today has the look of a place that has seen better days. In this painting, a sleazy hotel and bar form the backdrop for a lone prostitute who stands waiting on the corner. The car at the right has stopped, perhaps to do business. The lurid, neon-tinged shadows give an ominous cast to a scene that by day would be merely routine. This is not the New York of the Convention and Visitors Bureau.

Jane Dickson, born in Chicago in 1952, very often paints what she sees from her window in a studio close to Times Square.

WHITE HAIRED GIRL
Jane Dickson, 1983, oil stick on canvas, 90 x 40 inches.
Private Collection. Courtesy of Brooke Alexander, New York City.
Photo by Ion Abbott.

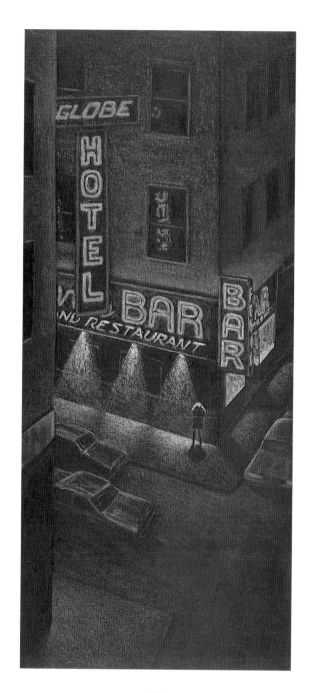

THE PAINTED CITY

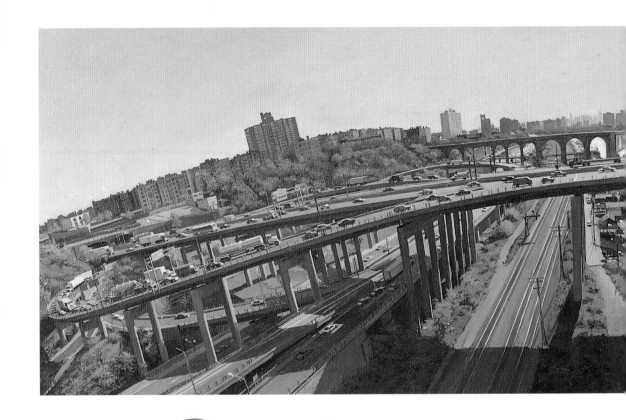

*V*IEWED AS IF FROM a low-flying helicopter,
this panoramic scene pays tribute to the lay-
ers of complex engineering that hold New
York City together. We are looking south from
the Bronx toward Manhattan. In the fore-
ground is a rollercoaster of road interchanges completed in 1964, 2.21 miles
of ramps designed to form a link between two heavily traveled highways, the
Major Deegan and the Cross Bronx expressways. The march of arches just
behind the overpasses is the old High Bridge at 175th Street, built to carry

THE CROSS BRONX EXPRESSWAY WITH THE HARLEM RIVER DRIVE
AND THE MAJOR DEEGAN INTERCHANGE
Rackstraw Downes, 1983, oil on canvas, 18 1/2 x 60 inches.
Courtesy of Hirschl & Adler Moderns, New York City.

across the Harlem River the pipes of the Croton Aqueduct, which brought water to the city from upstate. (The High Bridge Water Tower looms at right; at top center of the painting a cluster of skyscrapers in midtown Manhattan can be seen.) On the right is the Harlem River, bordered by the Harlem River Drive, that divides the boroughs of Manhattan (right) and the Bronx (left).

Rackstraw Downes, born in England in 1939, started out as an abstract painter, but today is noted for the luminous, sweeping views he paints of places from Manhattan to Maine to Texas. His landscapes are not those of romantic nostalgia; instead they convey a sense of complex social structure.

ETWEEN THE TWO World Wars, the glamorous arena known as the nightclub was at its peak in New York City. Frequented by the rich and the chic, who were known as "café society," places like El Morocco and the Stork Club were regularly covered by gossip columnists, who spread the names of club patrons and their doings from coast to coast.

Drink, dance, and gossip were the chief activities at these cabarets. But compared with clubs today, the atmosphere was staid and the dress code was formal, as we see in this 1933 painting. (Notice, however, that the lady in the right foreground has slipped off one of her shoes.) Small tables, packed closely together, didn't hold much more than a couple of drinks, but their relative distance from the dance floor indicated the customer's status. The societal revolution of the 1960s, the incursion of television, and the drift of the young to rowdier entertainment made the nightclub as extinct a social force as, say, the dowager.

Guy Pène DuBois (1884–1958) studied art in New York and Paris, but spent fifteen years as a journalist and art critic before devoting full time to painting. At home in "society," he was nevertheless a witty and satirical observer who obviously took a tongue-in-cheek view of affluent society at play. In this painting, he himself stands at the farthest right, next to a prominent art critic of the day, Forbes Robinson.

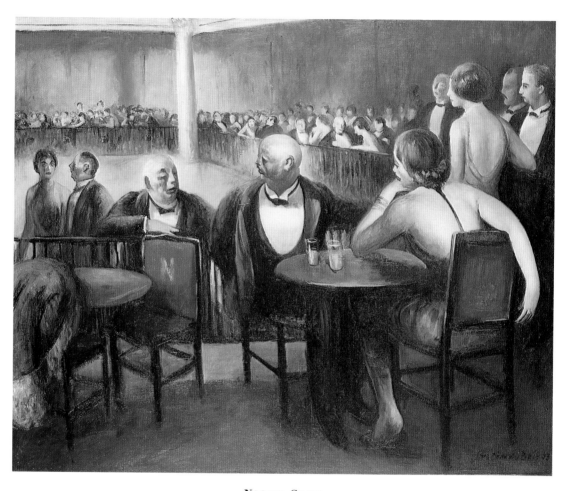

NIGHT CLUB
Guy Pène DuBois, 1933, oil on canvas, 29 1/8 x 36 inches.
Collection of the Hirshhorn Museum and Sculpture Garden, Smithsonian Institution, Washington, D.C.
(Gift of Joseph H. Hirshhorn, 1966). Photo by Lee Stalsworth.

THE BUILDING FROM which this painting takes its name is a flamboyant beaux arts landmark on New York's Upper West Side, an ornate wedding cake of an apartment hotel built in 1904. The unpretentious, unfashionable Upper West Side, with its commodious apartment buildings, has always attracted musical, dramatic, and literary talents, and the Ansonia's thick-walled flats have housed such musicians as Enrico Caruso, Igor Stravinsky, and Arturo Toscanini, along with actress Billie Burke and baseball player Babe Ruth. Since the Lincoln Center was built in the 1960s, the Ansonia's proximity to it has made it even more of an attraction for people in the performing arts.

In the painting, the Ansonia is seen in the distance, directly to the left of the tall Doric columns that loom in the foreground, although it is not reflected by the glass storefront of the flower shop (right foreground) that mirrors the street and other buildings. Using a photo-realist style, Richard Estes (born in 1936) likes to explore how the city's glittering surfaces of glass, steel, and polished stone compound the urban confusion of images.

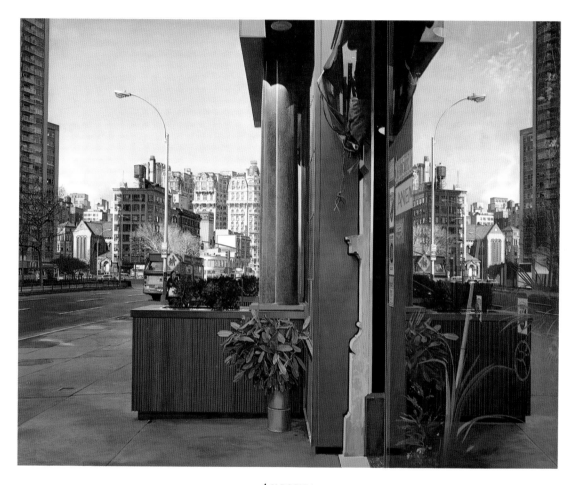

ANSONIA
Richard Estes, 1977, oil on canvas, 48 x 60 inches.
Collection of the Whitney Museum of American Art, New York City
(Purchase, with funds from Frances and Sydney Lewis).
Photo by Geoffrey Clements.

CENTRAL PARK, a vital part of New York's recreational life, is as alive with activity in the winter as it is in the summer. For generations every snowfall has brought children swarming to the park with sleds where, watched over by grownups, they take joyous advantage of the hilly terrain. In this painting Glackens has choreographed the action as carefully as a stage director might, from the rough-and-tumbling children to the sedate presence of a woman—the largest figure in the painting, perhaps a nanny or a parent—leaning against a tree.

Glackens, a member of the realist school of American painters known as The Eight, started out as a newspaper illustrator in Philadelphia. He came to New York in 1896 to join the staff of the *New York Herald* after studying art intensively in Paris. He immersed himself in New York life, and is best known for his crisp, sparkling views of it.

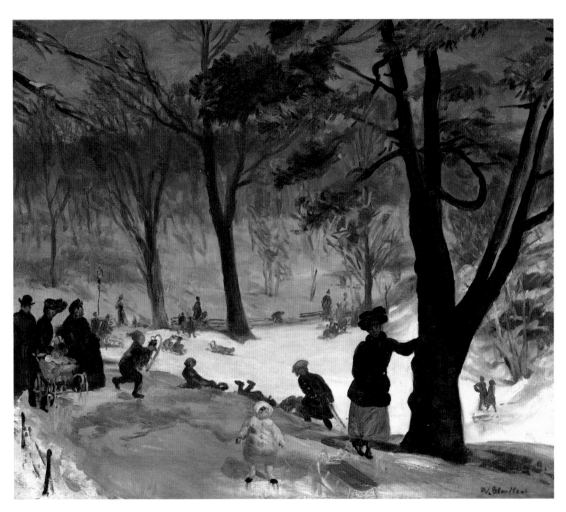

CENTRAL PARK IN WINTER
William James Glackens, 1905, oil on canvas, 25 x 30 inches.
Collection of the Metropolitan Museum of Art, New York City (George A. Hearn Fund, 1921).

G REENWICH VILLAGE IS one of New York's most picturesque areas; its buildings are among the oldest, many dating back to the early nineteenth century when it was an upper-class residential neighborhood. After the turn of the century, its narrow, crooked streets and rundown houses began to attract Bohemian artists and writers, and the legend of the Village as a haunt for creative talent was born. The setting in this painting is Washington Square Park, a center of Village life, and the two suspicious-looking characters on the bench are, in fact, famous painters, the abstract expressionists Mark Rothko (left) and Willem deKooning. Red Grooms, known for his comic visions of life in Manhattan, grew up under the influence of abstract expressionism and greatly admired these two older artists.

Chance Encounter, one of Groom's most ambitious paintings, celebrates an actual incident, related by deKooning in a newspaper interview. He told how he would take long, anguished walks at night when his work did not go well, and his first meeting with Rothko, who was experiencing the same turmoil, occurred on a bench in Washington Square Park.

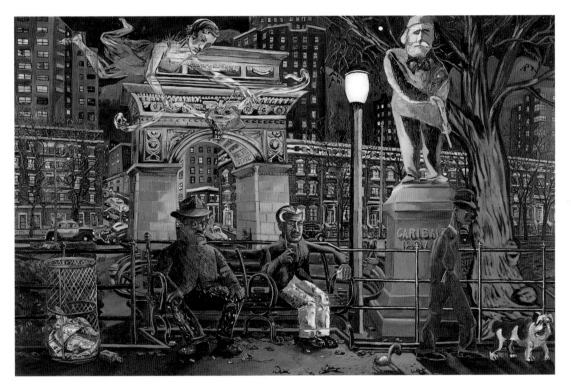

CHANCE ENCOUNTER AT 3 A.M.
Red Grooms, 1984, oil on canvas, 100 x 155 inches.
Collection of the Metropolitan Museum of Art. Courtesy of Marlborough Gallery.
© 1992 Red Grooms/Artists Rights Society, New York City.

*T*HIS DESOLATE GHETTO neighborhood, in the shadow of the Brooklyn Bridge, has a very different look from the sparkling New York scenes painted by the previous generation of artists, Sloan and Glackens among them. Done at the end of the Great Depression, which was precipitated by the stock market crash of 1929 but endured until the beginning of World War II, this painting symbolizes the despair that dogged many for whom paid work had long since come to a halt. The all-but-deserted street, surveyed by a melancholy woman from a tenement window, is a metaphor for an entire city caught in the Depression's grip.

At this period of his career, O. Louis Guglielmi (1906–1956) worked in a blend of realism and fantasy, born of feelings of personal, political, and social upheaval. He said that the stimulus for this and other of his works done in the 1930s and early 1940s was "the drama of the plight of humanity caught in the law of change."

A MUTED STREET
O. Louis Guglielmi, 1942, oil on canvas, 24 x 20 inches.
The Regis Collection, Minneapolis, Minnesota.

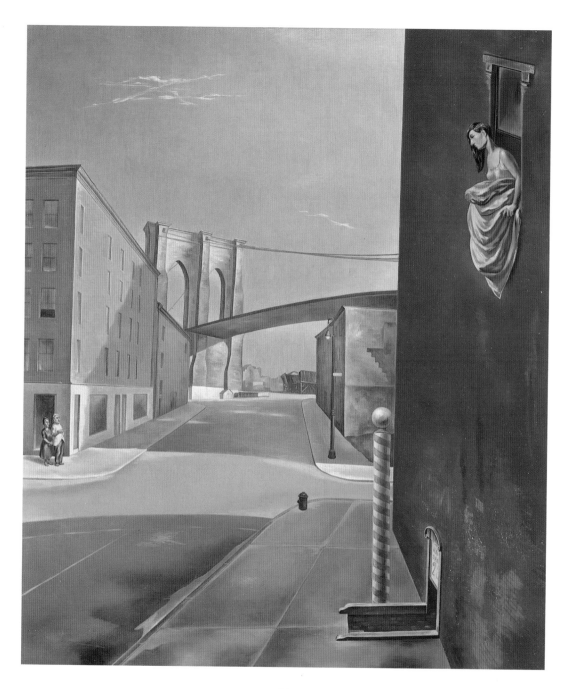

NE OF NEW YORK'S most painted and photographed icons, the twenty-story office tower known as the Flatiron Building was designed by the distinguished Chicago architect Daniel H. Burnham and unveiled in June 1902. The building's "flatiron" shape reflects its triangular plot, at the intersection of Fifth Avenue and Broadway between Twenty-second and Twenty-third streets, diagonally across from Madison Square Park. Construction of the Flatiron clinched the change of Madison Square, once the center of Manhattan's social life, into a commercial area. Already edging the little park were the Metropolitan Life Insurance Company, the Appellate Division of the Supreme Court, and Madison Square Garden, a sports and entertainment arena.

The Flatiron's odd shape, which changes according to the angle of view, was a continual challenge to artists, and among the many who responded was Samuel Halpert (1884–1930). The Russian-born American, schooled in Paris among the Fauves, took a northeast view of the building, depicting Madison Square Park in the foreground and at the extreme right the Fifth Avenue Building, which had replaced the resplendent Fifth Avenue Hotel in 1909. Halpert's painting is a charming evocation of the area, but in his hands the Flatiron takes on a one-dimensional, weighty look that gives little hint of its structural elegance.

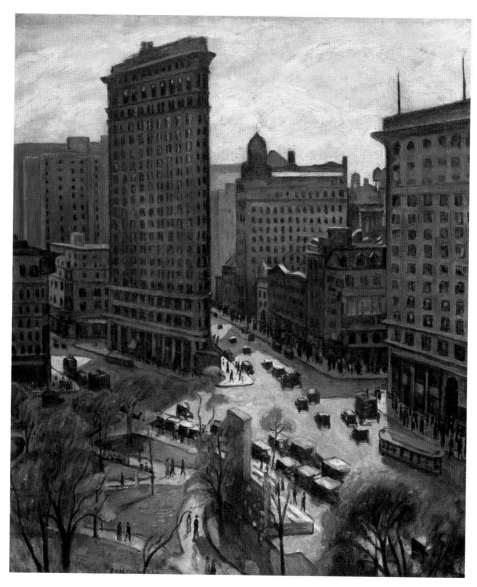

FLATIRON BUILDING (MADISON SQUARE)
Samuel Halpert, 1919, oil on canvas, 40 x 34 inches.
Collection of the Metropolitan Museum of Art, New York City
(Gift of Dr. and Mrs. Wesley Halpert, 1981).

*T*HIS ANIMATED SCENE is Madison Square, and when Childe Hassam painted it more than a century ago it was indeed the heart of upper-crust New York. Bounded by Twenty-third and Twenty-sixth streets and by Madison Avenue and the intersection of Fifth Avenue and Broadway, the square incorporates the patch of greenery known as Madison Square Park. Many of the city's social luminaries lived on its quiet side streets, and the main thoroughfares were lined with opulent hotels, restaurants, and cafés. The columned portico at left, fronted by gas lamps, a sidewalk clock and a congregation of hansom cabs, was the entrance to the Fifth Avenue Hotel, a six-story hostelry of white marble frequented by statesmen, politicians, and theatrical stars.

Childe Hassam (1859–1935), born a proper Bostonian, settled in New York after study in Paris and painted many cityscapes. He loved the energetic bustle of New York life and the views that the city presented. "The very thing that makes New York irregular and topsy-turvy," he once said, "makes it capable of the most astounding effects."

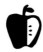

SPRING MORNING IN THE HEART OF THE CITY
Childe Hassam, 1890, oil on canvas, 18 1/8 x 20 3/4 inches.
Collection of the Metropolitan Museum of Art, New York City (Gift of Miss Ethelyn McKinney, 1943,
in memory of her brother, Glenn Ford McKinney).

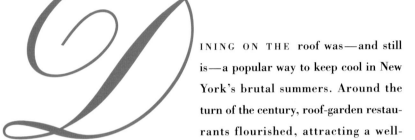

DINING ON THE roof was—and still is—a popular way to keep cool in New York's brutal summers. Around the turn of the century, roof-garden restaurants flourished, attracting a well-heeled clientele that didn't stint on champagne and other refreshments. This scene could almost be the old roof terrace of Madison Square Garden, where the architect Stanford White was shot to death by a jealous husband in 1906.

But, in fact, the artist, a Frenchman named Charles Hoffbauer, painted it in Paris from his imagination, after seeing photographs of New York in the nighttime glow cast by early skyscrapers. He had heard of the roof-dining custom from an American friend. This view of elegantly attired people in front of a dynamic skyline is one of several studies that Hoffbauer did for a larger painting he showed at the Paris salon in 1905. It was acclaimed for its "incontestable Americanism."

Hoffbauer (1875–1957) moved to the United States in 1909, where he remained for the rest of his life, becoming a prominent muralist here.

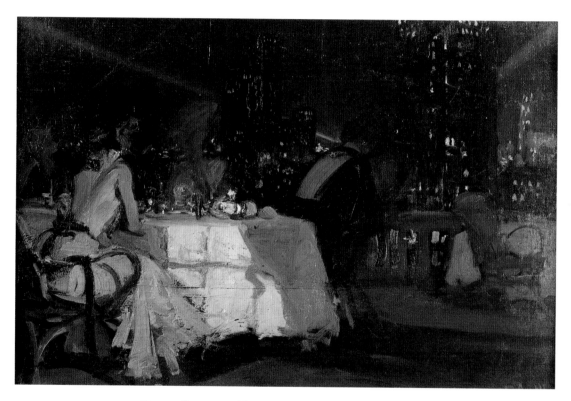

ROOF GARDEN (STUDY FOR "SUR LES TOITS")
Charles C. Hoffbauer, 1904, oil on canvas, 19 7/8 x 30 inches.
Museum of the City of New York, Robert R. Preato Collection, New York City.

*B*EFORE THE AMERICAN wars in Asia—Korea and Vietnam—gave Americans the experience of more exotic oriental cuisine, most Chinese restaurants in New York specialized in a watered-down pap known as chop suey. The restaurants were often to be found on the second floor of a down-at-heels building, and the meals they served were cheap and predictable. Such "chop suey joints" were often portrayed by New York artists, and in this painting Edward Hopper has focused on a place in Greenwich Village near the walk-up apartment where he and his artist wife, Jo, lived. She, in fact, posed for both figures in the foreground, wearing the cloche hat of the period, and her fur coat hangs on the wall.

As usual, the low-key subject that Hopper has chosen is imbued with a certain sadness; the restaurant with its dreary winter light seems to sap the energy from the diners. Hopper, who occupied the same apartment-studio in a brownstone on Washington Square for more than fifty years, was never interested in the glamorous aspects of Manhattan life, choosing instead to concentrate on its ordinary side and the isolation of urban experience. He once wrote about his work, "Each picture is an instant in time, arrested—and acutely realized with the utmost intensity."

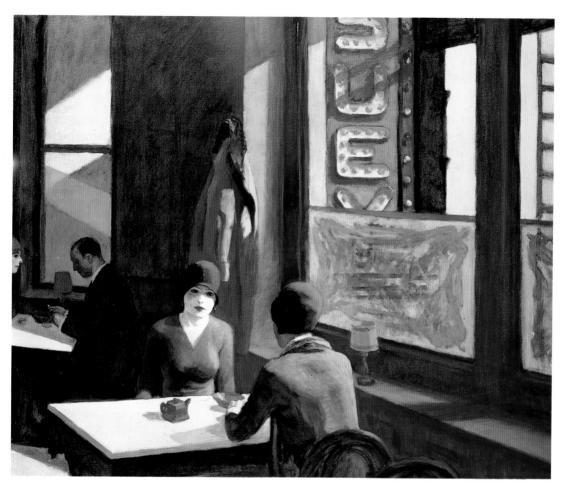

CHOP SUEY
Edward Hopper, 1929, oil on canvas, 32 x 38 inches.
Collection of Barney A. Ebsworth, St. Louis, Missouri.

T WOULD BE hard to guess from this austere scene on Broadway just off Columbus Circle that the area is one of the busiest in Manhattan. The place where Broadway, Eighth Avenue and Fifty-ninth Street meet at the southwest corner of Central Park has been known as Columbus Circle since 1892, when a seventy-seven-foot-high statue of Columbus by Gaetano Russo was erected there on the four hundredth anniversary of the discovery of America. (The Columbus monument is just south of this view.)

But Edward Hopper (1882–1967), famous for his images of urban loneliness, chose to portray this bustling spot at a moment—it would have to be very early in the morning—when it is virtually deserted. In the absence of people, the banal architectural elements in his paintings have a powerful presence and can convey, as here, a hauntingly melancholy mood. What we can see of the theater, with its up-to-the-minute art deco marquee and flashy announcement board, is in sharp contrast to the heavy Victorian architecture of the subway kiosk (neither theater nor kiosk are there today). New York is very much a place where the past impinges on the present, as this painting eloquently suggests.

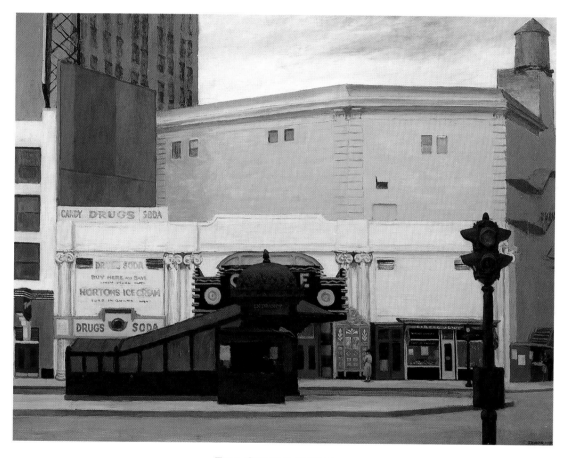

THE CIRCLE THEATER
Edward Hopper, 1936, oil on canvas, 27 x 36 inches.
Private collection. Courtesy of the Hirschl & Adler Galleries, New York City.

*P*LACID SHEEP ONCE grazed the vast, open sward of Central Park's Sheep Meadow, which on pleasant days now serves as picnic and recreation grounds for New Yorkers of every race, creed, color, and social status. On summer nights they assemble in the meadow to hear music ranging from opera to rock. Frederick Law Olmsted, who with Calvert Vaux designed the park in the mid-nineteenth century, saw it as a democratic gathering place for "poor and rich, young and old, Jew and Gentile," and would have been delighted by the rainbow mix that today frequents the park's 843 acres.

Bill Jacklin, an English-born artist, moved to New York from London in the mid-eighties to paint. He likes to focus on the doings of everyday New Yorkers, often portraying the tension and drama in crowd scenes. Of the hot, hazy setting in *Sheep Meadow*, filled with a volatile local crowd, he says, "One could describe the scene as disordered, but it's still a tranquil painting. The disorder hasn't broken down into chaos."

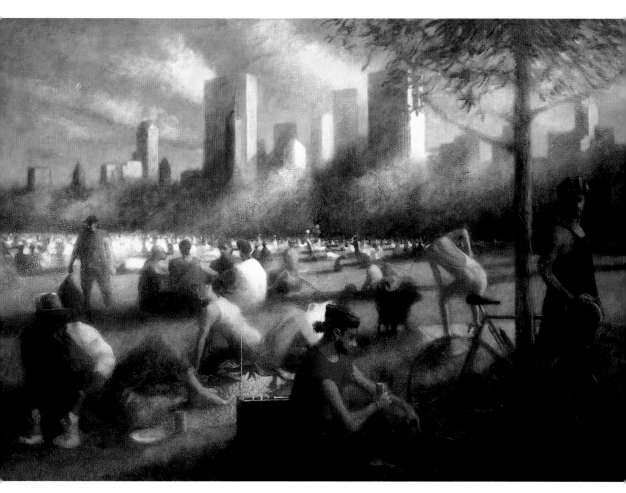

SHEEP MEADOW III
Bill Jacklin, 1990, oil on canvas, 96 x 144 inches.
Courtesy of Marlborough Gallery, New York City.

*T*HE CITY'S MOST glamorous waterway is the East River, which separates Manhattan and the Bronx from Queens and Brooklyn. It's not really a river at all, but a sixteen-mile long tidal estuary, spanned by eight bridges and extending north from the Battery at Manhattan's foot to Throg's Neck at the head of Long Island Sound. Along its Manhattan bank, at left in Yvonne Jacquette's dramatic night view, runs the Franklin D. Roosevelt Drive, built in the mid-1930s, and lined from Fortieth to Eighty-ninth streets with luxury riverfront houses and apartment buildings. The drive, the eastern leg of the roadway that encircles the island of Manhattan, carries cars as far uptown as the Throg's Neck Bridge and downtown to the Brooklyn-Battery Tunnel.

This painting, made from a high floor in a nearby building, shows the river and the drive from about Thirty-fifth Street to Fifty-ninth Street. The festive-looking span at right is the Queensboro—or Fifty-ninth Street—Bridge, linking Manhattan and Queens. Jacquette, who delights in composing her urban panoramas from the windows of planes and skyscrapers, often combines natural with man-made elements. Here the highway, alive with a bright, flowing ribbon of car headlights, is offset by the still, dark mirror that is the river's surface.

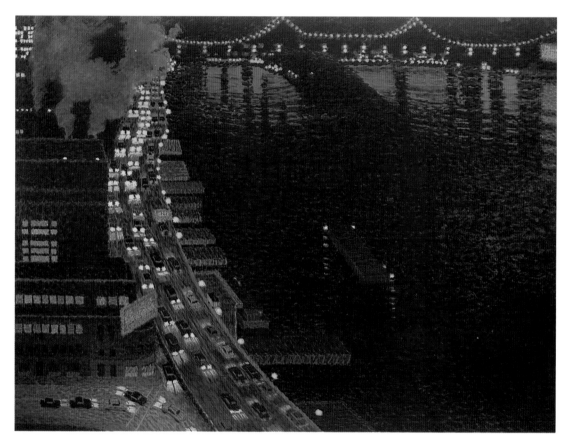

EAST RIVER AT NIGHT
Yvonne Jacquette, 1978, oil on canvas, 56 x 74 inches.
Private Collection. Courtesy of Brooke Alexander, New York City.

YVONNE JACQUETTE'S glittering trip-
tych celebrates the "new" Times Square,
where corporate products are hawked
by humongous electric signs that dwarf
the shrill marquees below them. But the
area is still the entertainment heart of
the city as it was a century ago. Then it
was called Longacre Square, after a district in London, and lined with the-
aters, cabarets, concert halls, and luxurious restaurants. (The name
changed to Times Square soon after the *New York Times* built its wedge-
shaped Times Tower in 1904 at the intersection of Broadway and Seventh

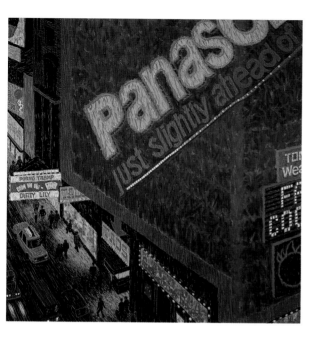

TIMES SQUARE TRIPTYCH II
Yvonne Jacquette, 1986–87,
oil on canvas, 3 panels—each 80 x 80 inches.
Courtesy of Brooke Alexander, New York City.

Avenue.) With the rise of the film industry in the 1920s, huge movie palaces displaced the older amusement structures—the grandest of all was the Roxy—but those have disappeared, too.

Now the square is host to "cinema centers" that show several films simultaneously, X-rated movie houses, fast-food outlets, tourist restaurants, and a few hotels. The nearly two dozen legitimate theaters remaining are mostly concentrated in one-block areas off the square, from Forty-fourth to Fifty-second streets. But if this triptych evokes the raffishness of Times Square today, its sizzling colors and sharp-angled view also convey the energy that keeps the square one of the city's major attractions.

NCE THE FAVORITE spot for soapbox orators, labor gatherings, mass political meetings, and Socialist May Day rallies, the 3.4-acre Union Square begins at Fourteenth Street and runs to Seventeenth, between Broadway and Fourth Avenue. It got its name not from any connection with the Civil War or labor unions, but from the fact that it was the "place of union" for two main roads, the Bowery and Broadway. A beautiful residential area before the Civil War, it became an uptown theatrical district; then commerce took over. Tiffany's, Brentano's, and an assortment of piano manufacturers lined its streets before the 1920s, but at the Depression-era time of this painting the square's most famous occupant was a discount fashion emporium known as "S. Klein's On the Square," where frenzied shoppers were known to tear garments from each other's grasp.

Several well-known artists had studios on the square in those days, among them Morris Kantor (1896–1974). He made it the subject of many of his paintings. *Farewell to Union Square* is a poetic goodbye in which three giant roses lie funereally over the scene. It was the last painting in a series he did before he moved out of the city to the country. "Everyday from my studio window I used to see two rows of cars posed in the same formation and people passing by in the same routine, which impressed me to be aimless," Kantor wrote, adding that he "threw in the roses" for good cheer.

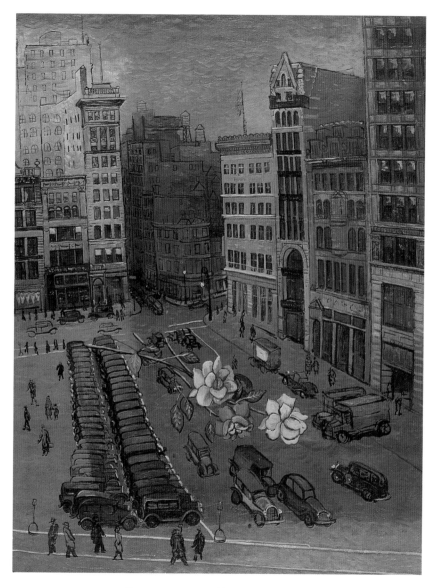

FAREWELL TO UNION SQUARE
Morris Kantor, 1931, oil on canvas, 36 x 27 inches.
Collection of the Newark Museum, Newark, New Jersey
(Purchase 1946, John Cotton Dana Fund).

THE SUPREME SYMBOL of New York's romantic skyline is the 102-story Empire State Building, once the tallest in the world but now surpassed by Manhattan's World Trade Center and the Sears Building in Chicago. Yet nobody can deny that the Empire is still alluring. Completed in 1931, in the last gasp of the skyscraper frenzy that gripped Manhattan in the 1920s, this quarter-of-a-mile-high office building has a cool, modernistic elegance that keeps it from showing its age. Its eventful career includes a starring role in the 1931 movie, *King Kong*, a plane crash in 1945 that did extensive damage to the seventy-eighth and seventy-ninth floors, and a visit from Fidel Castro in 1959.

On a trip to New York in 1966, the Viennese expressionist painter Oskar Kokoschka (1886–1980) painted Manhattan looking south, or downtown, from the thirty-third floor of a building on East Fortieth Street. The Empire State Building is the phallic tower that looms at the right, although for accuracy's sake, the building—on Fifth Avenue at Thirty-fourth Street—should be toward the middle of the composition. But that's artistic license.

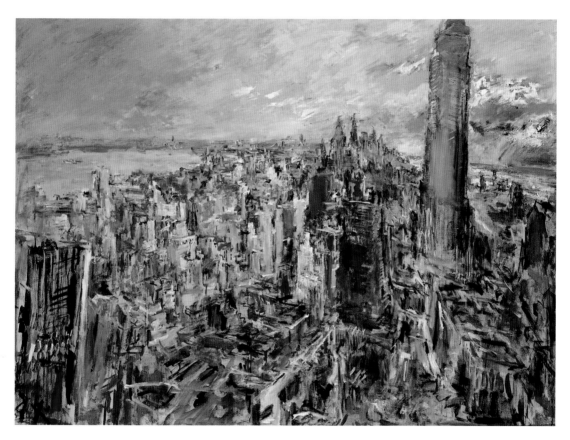

VIEW OF DOWNTOWN MANHATTAN WITH EMPIRE STATE
Oskar Kokoschka, 1966, oil on canvas, 40 x 53 inches.
Private collection, Ohio. Courtesy of Marlborough Gallery, New York City.

JACOB LAWRENCE, who once lived in Bedford-Stuyvesant, has painted an affectionate impression of the crossroads of this populous area, a three-and one-half-mile chunk of central Brooklyn. Blacks have had a presence in Bed-Stuy, as it is called locally, since the early 1820s, when a handful of freed slaves established a thriving settlement called Weeksville. In the second half of the nineteenth century, thousands more blacks poured into Bed-Stuy, some fleeing persecution that arose from the Civil War draft riots in Manhattan. Many lived prosperously, despite contemporary descriptions of the area as a slum. In the 1870s and 1880s, the thirteen-block enclave known as Stuyvesant Heights developed as a fashionable white neighborhood. The whites moved out at the turn of the century, but rows of their magnificent townhouses still survive.

Bed-Stuy is one of the country's worst centers of poverty and crime, but it has another, more positive side: the numerous blocks of well-preserved homes, many owned by families of skilled workers, civil servants and professionals. In Lawrence's collage-cubist style of narrative painting, he shows the commercial center of the area, with its lively crowd of shoppers, vendors, and hangers-out. The last decade has brought a new influx of black professionals and working-class people, and there are signs that Bed-Stuy may be reversing its long deterioration.

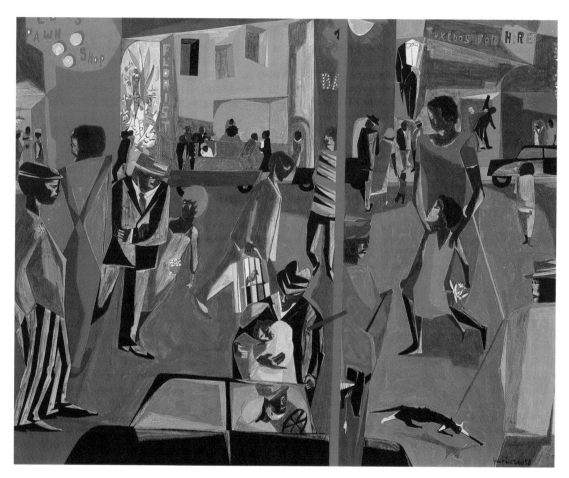

FULTON AND NOSTRAND, BROOKLYN
Jacob Lawrence, 1958, oil on canvas, 24 x 30 inches.
Collection of Joyce and George Wein. Photo by Pollitzer, Strong & Meyer, New York City.

*V*IEWED FOR THE first time or the hundredth, Manhattan towering above its sheltered harbor is a stunning sight, as romantic yet forbidding as a walled medieval castle. For John Marin, who turned from architecture to painting, its unplanned welter of skyscrapers expressed the city's raw energy and power like no other symbols. "To pile these great houses one upon another with paint as they do pile themselves up there so beautiful, so fantastic—at times one is afraid to look at them but feels like running away," Marin wrote.

Marin (1870–1953) was born in Rutherford, New Jersey, and studied art in Philadelphia, New York, and Paris. One of America's greatest watercolorists, his favorite subjects were Maine and Manhattan. This lyrical hymn to the city was one of a strong group of New York paintings produced in 1921.

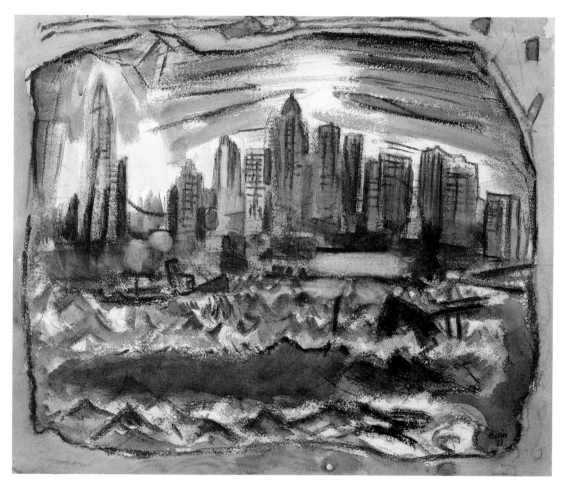

LOWER MANHATTAN FROM THE RIVER, NO. 1
John Marin, 1921, watercolor on paper, 21 1/2 x 26 1/2 inches.
Collection of the Metropolitan Museum of Art, New York City
(The Alfred Stieglitz Collection, 1949).

BACK IN THE DAYS when you could see a double feature for twenty cents, the Lyric Theater, on Forty-second Street near Broadway, had a "grind" schedule of continuous showings. The theater had seen better days, as evidenced by its splendidly ornate design—it was built in 1903 as a "legitimate" theater for the Shubert Brothers—and so had many of its customers. But for Reginald Marsh (1898–1954), a former newspaper cartoonist who loved urban tackiness and stalked it in the streets, at beaches, in theaters and amusement arcades, the movie palace and its customers were the very stuff of art. In this painting, he has made everything an object of display: the posturing people, the signs, the theater itself. They are all of a piece with the flicks that played inside.

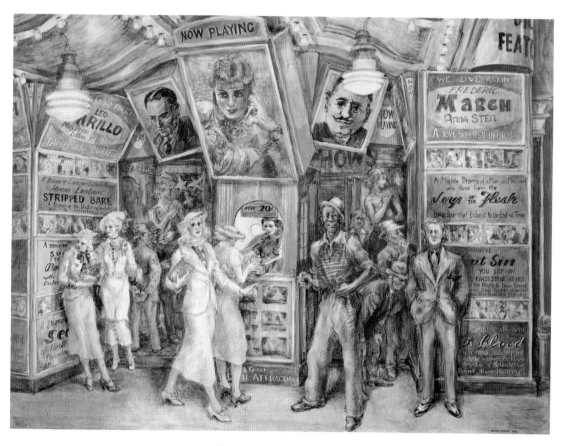

TWENTY CENT MOVIE

Reginald Marsh, 1936, egg tempera on composition board, 30 x 40 inches.

Collection of the Whitney Museum of American Art, New York City.

Photo by Geoffrey Clements.

 TRUE TRIBUTE TO New York is this totally abstract painting by the Dutch nonobjective painter Piet Mondrian (1872–1944). It pays homage to the energy of the city's main thoroughfare and to the improvisational style of jazz piano known as boogie-woogie that he heard here. Mondrian, who came to New York in 1940 when the Nazis invaded his homeland, was entranced by the glitter of Manhattan. He loved jazz and dancing, and his interest in the music led him to add rhythmic accents—small rectangles of color—to his austere paintings, a few strong, straight, black lines with square or rectangular spaces of white or primary hues.

"He responded to the modernism of New York, to the vast glittering modules of its skyscraper walls, its Africa-inspired dance rhythms," wrote the critic Harold Rosenberg about Mondrian's New York paintings. The artist himself said, "In the light of my experiences here, my paintings now have more boogie-woogie."

B ROADWAY B OOGIE-W OOGIE
Piet Mondrian, 1942–43, oil on canvas, 50 x 50 inches.
Collection of the Museum of Modern Art, New York City (Given anonymously).

A SYMBOL OF FREEDOM throughout the world, the French-made Statue of Liberty was inaugurated in New York Harbor on 28 October 1886, in an ebullient explosion of sound and light. President Grover Cleveland, a delegation of dignitaries from France, and a cast of thousands assembled on Bedloe's Island where the majestic Ms. Liberty, weighing 225 tons and stretching 151 feet high (on a 155-foot pedestal), stood with her face veiled. Auguste Bartholdi, Liberty's sculptor, was waiting inside her head. At a signal from an official on the ground, he pulled a cord that released the veil. The roar that went up, from a twenty-one-gun salute, boat whistles, foghorns, firecrackers, and human throats, reverberated through the city.

This idealized painting of the dedication by Edward Moran (1829–1901) was completed before the actual event, however. Moran, a marine and landscape artist from Philadelphia, began painting the dedication of Liberty in 1876 after meeting Bartholdi and seeing the torch of his proposed statue. Fired up, he created an image to show how Liberty would look installed on Bedloe's Island, and painted several other imaginary dedications before the real thing happened. In this one, for example, the base of the statue is slightly different from the original, and there's no hint of the bad weather which all but obscured Ms. Liberty on her inaugural day.

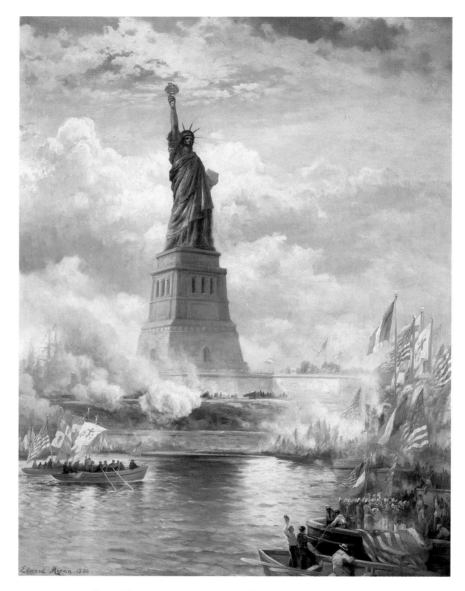

THE UNVEILING OF THE STATUE OF LIBERTY,
ENLIGHTENING THE WORLD
Edward Moran, ca. 1886, oil on canvas, 49 1/2 x 39 1/2 inches.
Museum of the City of New York, J. Clarence Davies Collection, New York City.

*S*HOOTING UPWARD IN the 1920s, Manhattan resounded with the noise of building, and at night the rapidly growing ranks of skyscrapers blazed with light from roofs and long ribbons of windows. Prominent among the newer arrivals was the American Radiator Building (now known as the American Standard Building) on West Fortieth Street between Fifth and Sixth avenues, overlooking Bryant Park and the New York Public Library. Designed by the sleek streamliner Raymond Hood and completed in 1924, it has a façade of black brick with the top picked out in gold terracotta—a twenty-one-story epitome of the city's glamor.

The young Georgia O'Keeffe lived with her husband, photographer Alfred Stieglitz, at the Shelton Hotel in midtown New York. She was much taken with the Radiator Building, which she saw when she walked on Forty-second Street. To her it was a symbol of the excitement and energy of New York, which she also celebrated by putting Stieglitz's name up high in a glow of red neon.

RADIATOR BUILDING—NIGHT, NEW YORK
Georgia O'Keeffe, 1925, oil on canvas, 48 x 30 inches.
Collection of the Carl Van Vechten Gallery of Fine Arts, Alfred Stieglitz Collection,
Nashville, Tennessee. With permission of the Georgia O'Keeffe Foundation.
Photo courtesy of Callaway Editions, New York City.

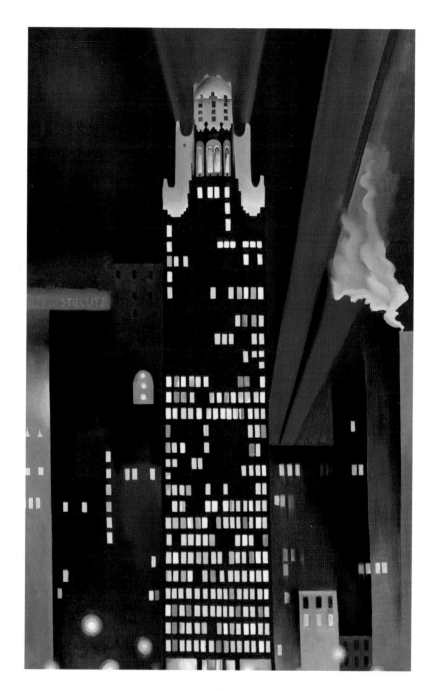

THE PAINTED CITY

NONYMOUS AS THEY may seem, Manhattan's streets have their individual profiles, and Fifty-sixth Street is no exception. This section of it (looking east from Sixth to Fifth Avenue) is part of a luxury shopping district where jewelry stores, art galleries, and women's specialty shops abound. Speaking of the area in a 1920s guidebook, one writer rhapsodized, "Things brought from the earth's four corners, filmy, exquisite, rich and rare sift through these specialty shops to the hands of the luxurious." Cyrano's, the elegant little restaurant at left, is no longer there, but the building with the row of arches at right is still occupied by the dazzling diamond emporium of Harry Winston.

Fairfield Porter (1907–1975), one of New York's most admired realist painters, considered this view one of his more difficult painting problems, possibly because of the difference in building scales, the afternoon light, and the random quality of the architecture. But as the "portrait of a New York street" that he intended, it's a good likeness.

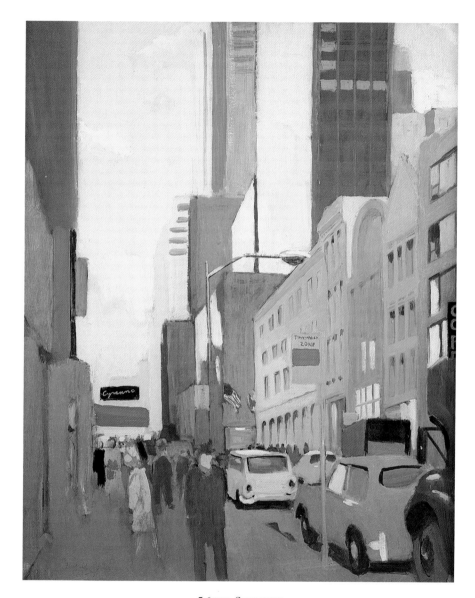

56TH STREET
Fairfield Porter, 1968–71, oil on canvas, 36 x 28 7/8 inches.
Estate of Fairfield Porter. Courtesy of Hirschl & Adler Moderns, New York City.
Photo by Zindman/Fremont.

EW YORK PARKS are true democracies, and at the turn of the century Upper East Side tenement kids and the more privileged mingled in the small recreation area known as East River Park. At the foot of East Eighty-sixth Street, fronting on the river, the park was especially geared to the pleasure of children (note the pony carts in the playground area at the left)—and the ease of their caretakers (note the comfortable benches). Next to the lamppost at left, a nanny in stiffly starched whites attends a posh, sunshaded perambulator. But the park faced a grim scene in mid-river: the buildings on what was then called Blackwell's Island (now it's Roosevelt Island), which included hospitals, a jail, a lunatic asylum, and a "poor house."

Maurice Brazil Prendergast (1859–1924) was an exceptionally fluent watercolorist, whose idyllic canvases often depicted upper-class people at leisure. Yet there are realist elements in this painting—the tugboats, the city buildings, the stacks belching smoke—not unlike the imagery in the down-to-earth Ashcan School of realists (John Sloan, William Glackens, Robert Henri, and others) that he later joined.

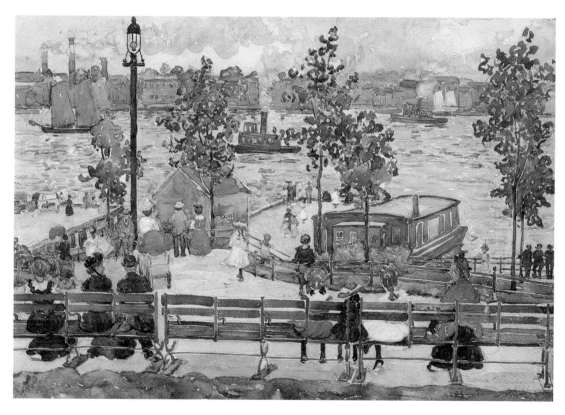

EAST RIVER PARK
Maurice B. Prendergast, 1901, watercolor on paper, 14 x 20 inches.
Courtesy of the Hirschl & Adler Galleries, New York City.

NEW YORK HAS its share of confrontations between citizens and the police, and this painting commemorates one of them. "ABC" does not refer to a television broadcasting company, but to the mean, drug-ridden streets of the Lower East Side: Avenues A, B, and C (there is also a D). And it is the slang name for an abandoned school building on East Fourth Street near Avenue B. In October 1989, a group of squatters evicted heroin addicts who had usurped the building and tried to set up a community center for the homeless. In turn, the police came to oust the squatters, and a night of violence ensued. More than thirty people were arrested.

The school itself is the dark building in the background, with the block in front of it sealed off. A burning dumpster stands between riot-geared police and the charging crowd. James Romberger, who lives in the neighborhood, was a spectator at the battle (he can be seen below the far end of the pizza sign at left, holding his infant son on his shoulders). This is one of many paintings that the artist, born in 1958, has done of the blighted East Village, an area where he finds "real beauty in the decrepitude."

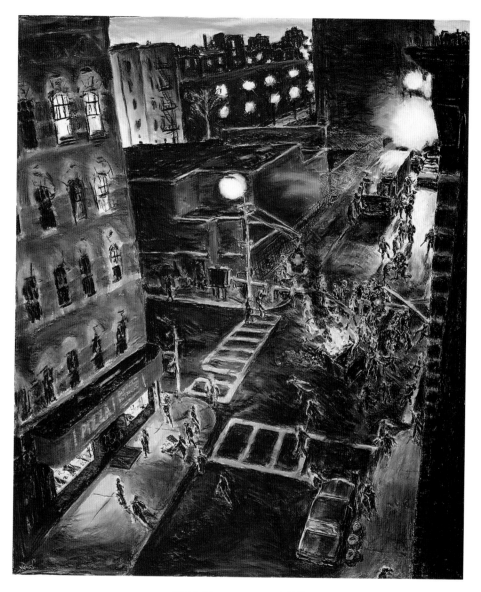

THE BATTLE OF ABC
James Romberger, 1991, pastel on paper, 60 x 50 3/8 inches.
Collection of the Metropolitan Museum of Art (Purchase, Dr. and Mrs. Robert E. Carroll Gift, 1991).
Courtesy of Grace Borgenicht Gallery, New York City.

71

B ROADWAY, ONE OF THE most famous streets in the world, is the longest in the city, meandering for nineteen miles from the Battery at the tip of Manhattan through the Bronx and into Westchester County. In this bustling view of Lower Broadway, then the heart of the city, New Yorkers are riding the Broadway Line, which used horse-drawn sleighs when the streets were snowy. The scene is complicated by firemen rushing into action at an imposing building at left, one of the many cast-iron fronts that still adorn this part of the city.

Hippolyte Sebron, a French painter who visited America from 1849 to 1855, spent the last year in New York City, where he found street activity much to his liking. The scene is rendered with a delightful architectural precision that doesn't detract from the liveliness of what's going on.

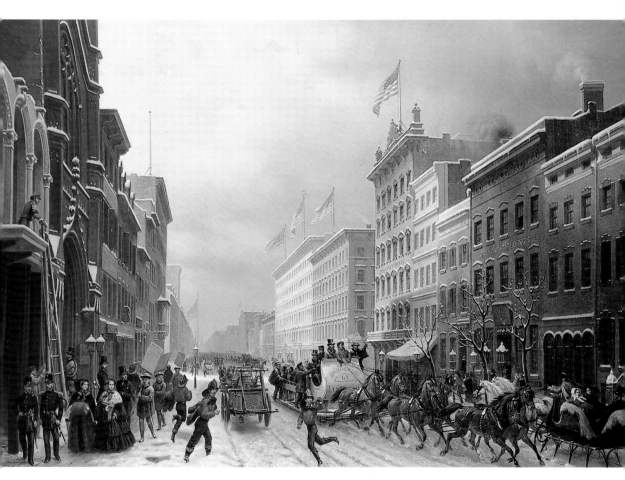

BROADWAY AT SPRING STREET
Hippolyte Sebron, 1855, oil on canvas, 29 1/4 x 42 1/2 inches.
Courtesy of the Schweitzer and Graham galleries, New York City.

*I*N THE BOOM YEARS of the 1920s, corporations swarmed to New York to take up residence in the mushrooming new skyscrapers. Midtown Manhattan was choked with office buildings, of varied sponsorship and uneven architectural merit. There seemed no limit to the city's upward mobility, physically embodied in its corporate towers.

In this optimistic era, Charles Sheeler (1883–1965) sang the praises of industry and technology in paintings and photographs. The geometric forms of the new buildings suited his cubist-derived precisionist style. The dense bank of skyscrapers he portrayed in this midtown Manhattan scene is a tribute to New York as the country's financial powerhouse.

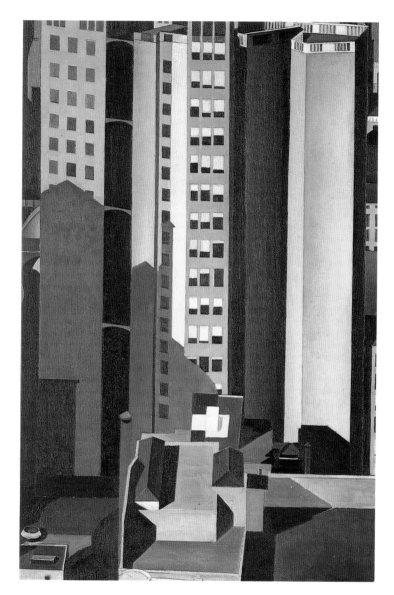

SKYSCRAPERS
Charles Sheeler, 1922, oil on canvas, 20 x 13 inches.
The Phillips Collection, Washington, D.C.

*I*N THE EARLY twentieth century, for the first time in American history, many single women came to cities like New York, got jobs, and led lives independent of their families. This urbanization of the young American female brought with it vast social changes. In this painting, made before hair dryers, three friends take advantage of their sunny "backyard"—a tenement rooftop—to perform a Sunday chore. They share a lively conversation that could be about work or maybe men.

Though John Sloan, a member of the gritty group of painters known as the Ashcan School, worked in other areas of the country, he's best known for his vigorous impressions of New York. "His art had the quality of being a direct product of common life, absolutely authentic and unsweetened," wrote the art historian Lloyd Goodrich. In 1912, Sloan was able for the first time to take a studio apart from his living quarters, on the eleventh floor of a building at Sixth Avenue and West Fourth Street, which gave him a view of neighboring roofs.

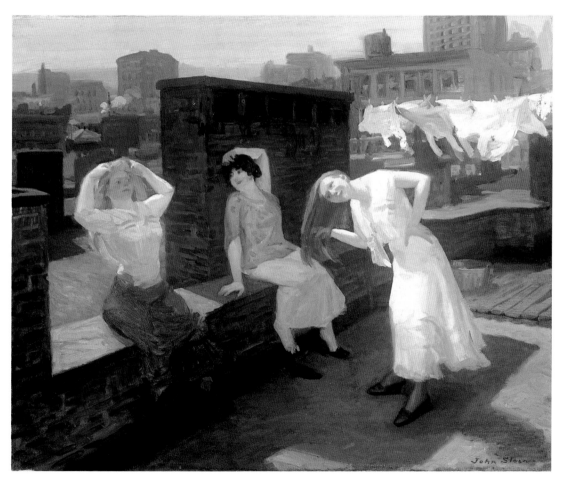

SUNDAY, WOMEN DRYING THEIR HAIR
John Sloan, 1912, oil on canvas, 26 x 32 inches.
Collection of the Addison Gallery of American Art, Phillips Andover Academy,
Andover, Massachusetts.

*T*HE ELEVATED RAILWAY, which by 1880 ran on steel superstructures along Second, Third, Sixth and Ninth avenues, provided the first really rapid transportation in New York City, whose slow-moving cobblestoned streets were hopelessly clogged with horse and pedestrian traffic. The first subway line, the IRT, was opened in 1904, but the "els" were slow to disappear, and roared overhead through the city until the 1940s. Both the "el" and the subway made cheap, fast transportation available to millions of New Yorkers. For many years, the fare was a nickel.

John Sloan (1871–1951) had a studio in the triangular loft building at the right of this 1922 painting. (The buildings on the left were about to be demolished to make way for more modern ones.) He viewed the "el" as a symbol of the city's vitality, to which the painting pays homage. As the Sixth Avenue train rumbles uptown past West Fourth Street on a rainy evening, it seems to generate a glow throughout the neighborhood. In the left background, the "power towers" of Wall Street are bathed in a symbolic luminosity.

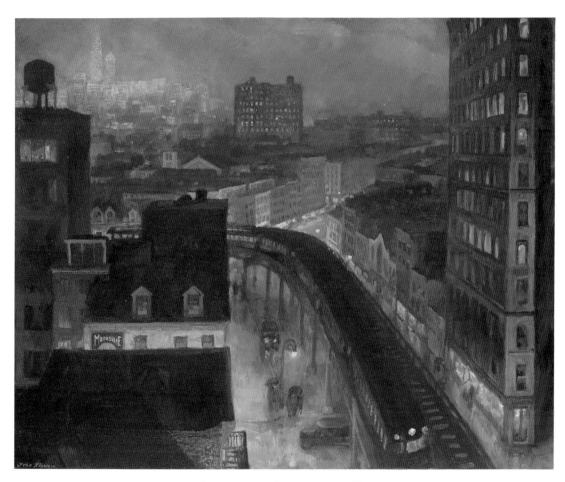

THE CITY FROM GREENWICH VILLAGE
John Sloan, 1922, oil on canvas, 26 x 33 3/4 inches.
Collection of the National Gallery of Art, Washington, D.C.
(Gift of Helen Farr Sloan).

Coney Island! Although most of it's gone now, the honky-tonk funland at the southwestern tip of Brooklyn is part of our national consciousness. And why not? It brought thrilling spectacles, hair-raising rides, brassy sideshows, and tasty hot dogs to generations of Americans. Coney—the name is thought to be derived from the Dutch word for "rabbit"—had a long career as a posh resort and then as a sports and gambling arena before it blossomed as the world's most spectacular amusement park in the 1890s, when rides like the Ferris wheel were introduced.

In 1920, the subway was extended to this coastal part of Brooklyn, making Coney and its beach available to millions of working-class New Yorkers. A nickel fare brought access to hours of high-pitched entertainment. When Joseph Stella painted Luna Park—built in 1903—it was one of three Coney fun spots. It covered fifty acres and blazed with more than a million electric bulbs. Among its attractions were a broad lagoon, a spacious ballroom, and the biggest herd of show elephants in the world. Alas, Luna burned down in 1947. But by then Coney's era was beginning to fade, and it was never rebuilt. As the public's interest turned to theme parks like Disneyland, Coney became a skeleton of its former self, and today there are only a few rides and hot dog vendors left. Still, the memories linger on.

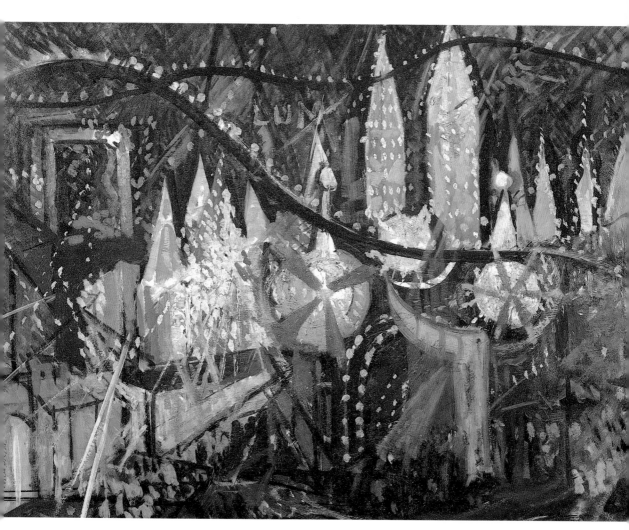

LUNA PARK
Joseph Stella, 1913, oil on composition board, 17 1/2 x 23 3/8 inches.
Collection of the Whitney Museum of American Art, New York City
(Gift of Mrs. Charles A. Goldberg). Photo by Geoffrey Clements.

*S*INCE ITS OPENING (to traffic) on 24 May 1883, the Brooklyn Bridge, that marvel of engineering and architectural elegance, has had a remarkable impact on artists and writers. With its high-arched granite towers and vast curving cables, the bridge—stretching more than a mile to unite the boroughs of Brooklyn and Manhattan—is the most romantically picturesque of the sixty-one spans that bind New York to the larger world. It inspired the poet Hart Crane's epic, *The Bridge*, and prompted the artists Joseph Stella and John Marin, among many other celebrants, to produce a number of painterly tributes.

For Stella (1877–1946), whose art was influenced by industrial-minded Italian futurists, the bridge was the supreme symbol of the city's spirit, the embodiment of the American dream. Observing it, he once wrote, "I felt deeply moved, as if on the threshold of a new religion, or in the presence of a new divinity." In his earlier career, he painted several monumental versions of the bridge, but in 1939, seven years before his death, he revisited the mighty span and painted it once more, this time giving it the look of an art deco icon.

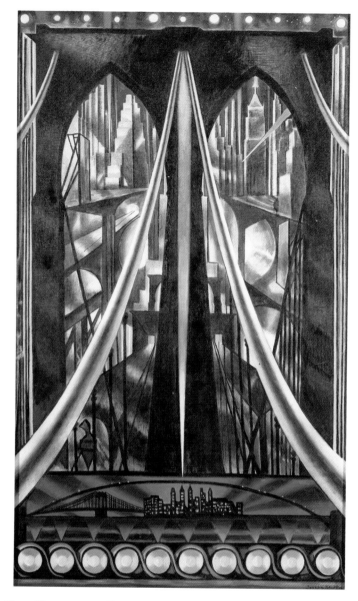

THE BROOKLYN BRIDGE: VARIATION ON AN OLD THEME
Joseph Stella, 1939, oil on canvas, 70 x 42 inches.
Collection of the Whitney Museum of American Art, New York City.
Photo by Geoffrey Clements.

THE VAST Grand Central terminal, which sprawls across Park Avenue between Forty-second and Forty-fifth streets, is one of the world's great railroad passenger depots. Since Pennsylvania Station, New York's other great depot, was all but demolished in 1963, Grand Central stands alone as a truly grand—if somewhat forlorn—monument to the much eroded concept of rail travel. The imposing main concourse, lavishly paved with marble, is 120 feet wide, 275 feet long and 125 feet high. In the terminal's peak years, before airlines encroached on its business, more people than the population of the United States passed through it annually, and its double-deck railroad yard, with forty-one tracks on the upper level and twenty-six on the lower, carried more than five hundred trains a day. Formalities were even observed. Shortly before the Twentieth Century Limited left for Chicago at 6:00 P.M. every day, a gray and red carpet was unrolled between the gate and the platform.

When Max Weber (1881–1961) made this ebullient painting in 1915, the present Grand Central terminal—built by the New York Central Railroad to replace the old depot on the same site—had been open for only two years. An expression of vigorous faith in the city's future, it was greatly admired as an engineering marvel for its economic use of available space. Weber, steeped in modernist movements during a hitch in Paris, used a cubist idiom to portray the terminal's ornate structure, juggling columns, arches, cornices, and sculptural embellishments to give an impression of the building—and the city—at its most frenetic.

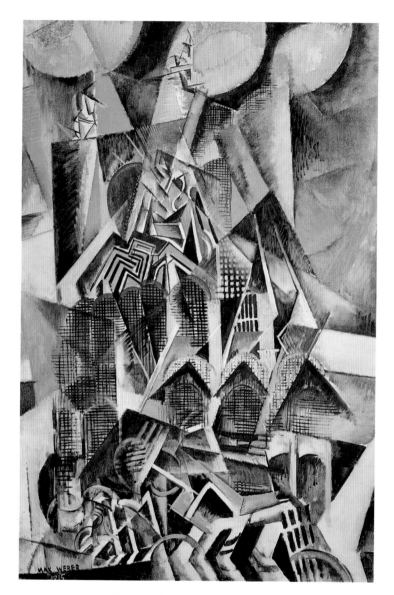

GRAND CENTRAL TERMINAL
Max Weber, 1915, oil on composition board, 59 1/2 x 40 inches.
Thyssen-Bornemisza Collection, Lugano, Switzerland.

*I*TS LITTLE PARK has been handsomely refurbished; there's a farmer's market on Saturdays, and a colossal new residential-office tower holds down its east corner. But Union Square today is not one of Manhattan's most attractive public spaces. If the painter Morris Kantor, who eulogized it in his 1931 painting, *Farewell to Union Square*, could see it now, he'd find little to celebrate with roses. Nearly sixty years later, too much of the square is a garish medley of fast-food places, cut-rate clothing shops, scabrous buildings, potholed streets, and ugly signage. It has a ramshackle, Third World look that would horrify the swells who lived in grand houses there before the Civil War.

Winter, who lives in Texas, has turned a pitiless eye on the blighted part of the square. In a painting almost the size of a billboard, he gives an eloquent visual account of its tackiness. A photo-realist, he starts out by making camera views of his subjects, but on the canvas strokes the paint in to suggest, rather than mimic, details. Once Buckminster Fuller, the futurist engineer, said to him, "Your paintings reflect the end of an era," and this view of Union Square would seem to bear that out.

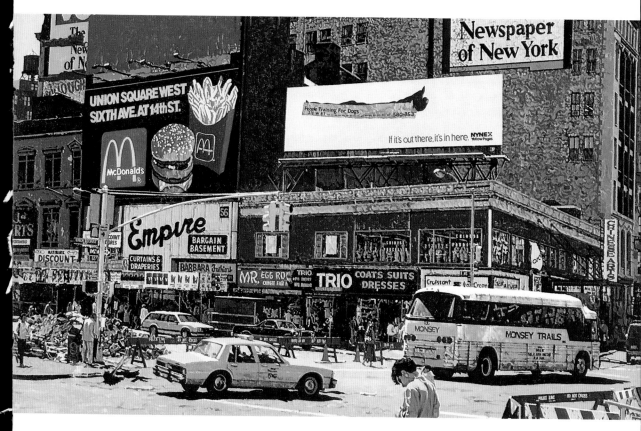

UNION SQUARE
Roger Winter, 1988, oil on canvas, 72 x 120 inches.
Courtesy of the Fischbach Gallery, New York City.
Photo by Plakke/Jacobs.

ACKNOWLEDGMENTS AND ADDITIONAL CREDITS

The author and publisher wish to thank the galleries, museums, collectors, and artists who helped us gather these paintings. In the credit lines, the phrase "courtesy of ..." is generally used to acknowledge the party from whom we obtained a reproducible transparency, if different from the copyright holder or owner of the painting.

We extend special thanks to the living artists, who have generously allowed their works to appear, and who continue to create memorable images of one of America's greatest cities.

The short quote on the jacket flap is from E. B. White's essay "Here is New York" (© 1949). It was first printed in *Holiday*, and has been available in a number of editions since then.

The stanza from Horace Gregory's " The Unwilling Guest: An Urban Dialogue," which serves as an epigraph for this book, appeared in *The Selected Poems of Horace Gregory* (© 1951), published by the Viking Press.